Phaidon Press Limited
140 Kensington Church Street
London W8 4BN

First published in Great Britain 1993
© Parramón Ediciones, S.A. 1993

ISBN 0 7148 2821 1

A CIP catalogue record for this book is available from the British Library

Printed in Spain

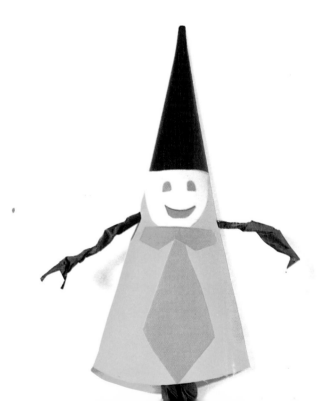

MSC

HAVE FUN MAKING
PUPPETS

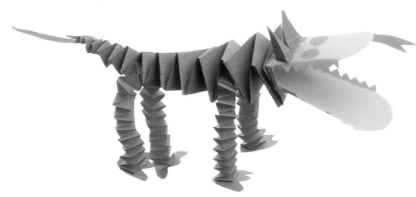

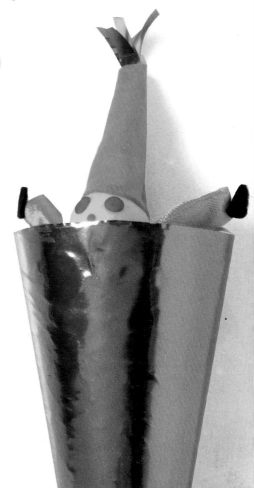

Φ

Two kittens

You will need card and coloured paper, felt and two drinking straws.

Cut out two round pieces of card and with one begin making the first face.

Stick them on to the face, then the face on to the end of a straw.

Trace and cut out, in paper and felt, the details: eyes, whiskers, ears...

Do the same with the other card circle... and you will have two sweet little kittens.

Ballerina

Get some coloured card and on one piece draw a ballerina shape.

On another piece draw a face, cut it out and decorate it.

Cut out your ballerina drawing. Make two holes for your fingers to fit through.

Put your fingers through the holes. Now she looks like a real ballerina!

Make a top, a bow and a skirt with holes and stick everything on to the body you have made.

Finger puppets

You will need two pieces of material like this, plasticine and felt.

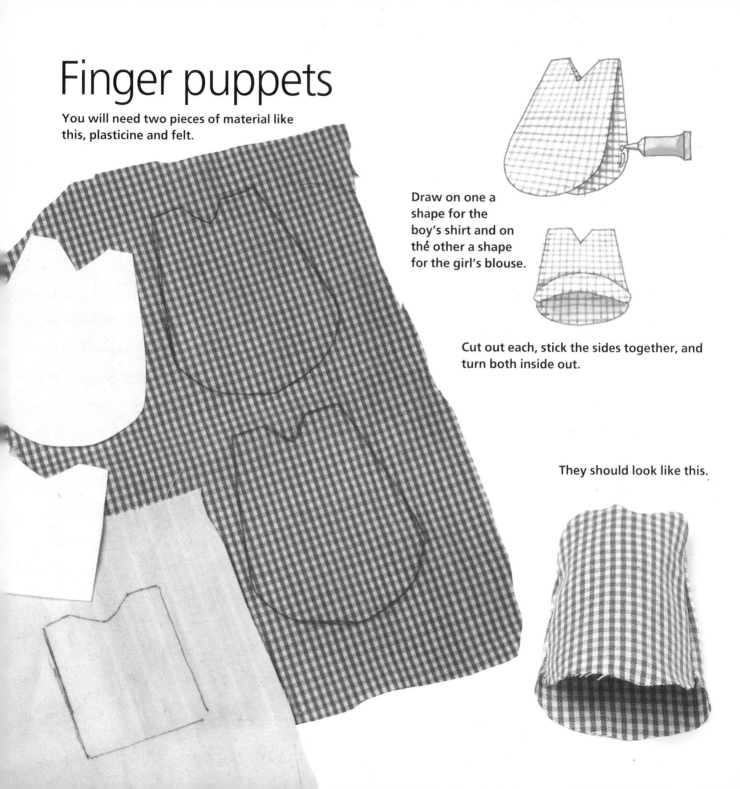

Draw on one a shape for the boy's shirt and on the other a shape for the girl's blouse.

Cut out each, stick the sides together, and turn both inside out.

They should look like this.

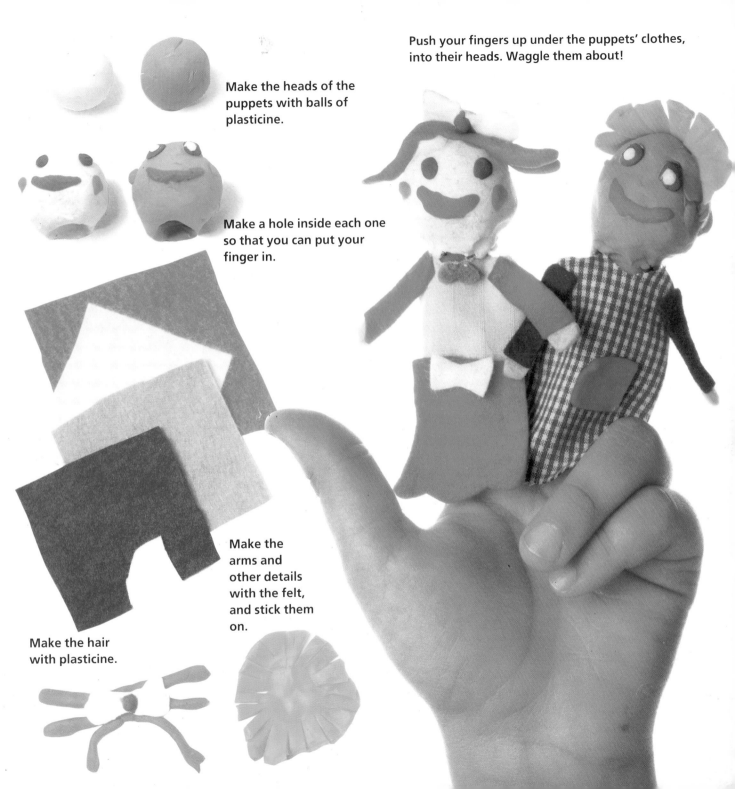

Make the heads of the puppets with balls of plasticine.

Make a hole inside each one so that you can put your finger in.

Push your fingers up under the puppets' clothes, into their heads. Waggle them about!

Make the arms and other details with the felt, and stick them on.

Make the hair with plasticine.

A spoon puppet

As well as pieces of card like this, you will need felt, crêpe paper and a plastic spoon.

Draw a clown's costume, hat, frills, hands, shoes and dots on different-coloured card. Cut them out.

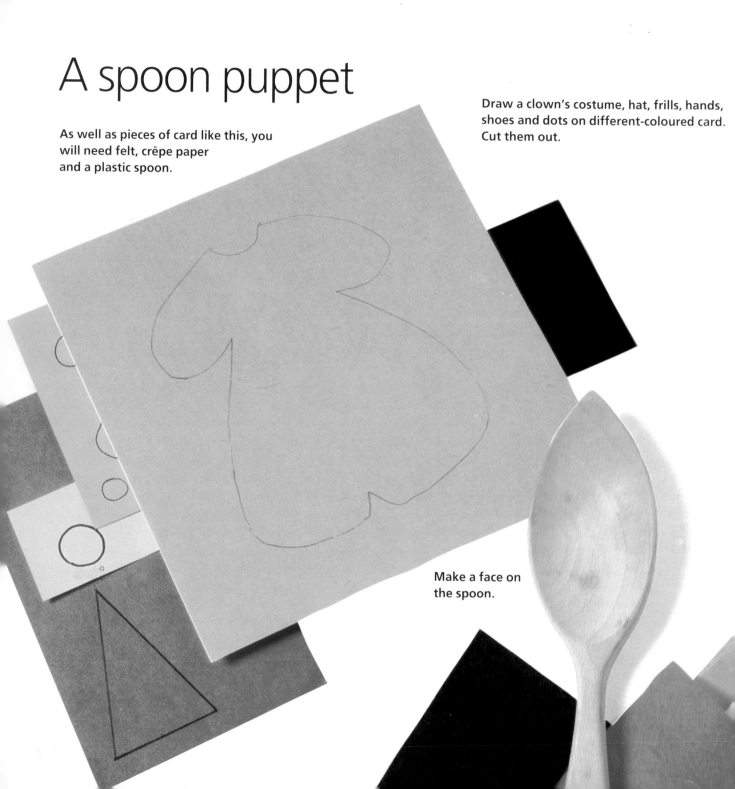

Make a face on the spoon.

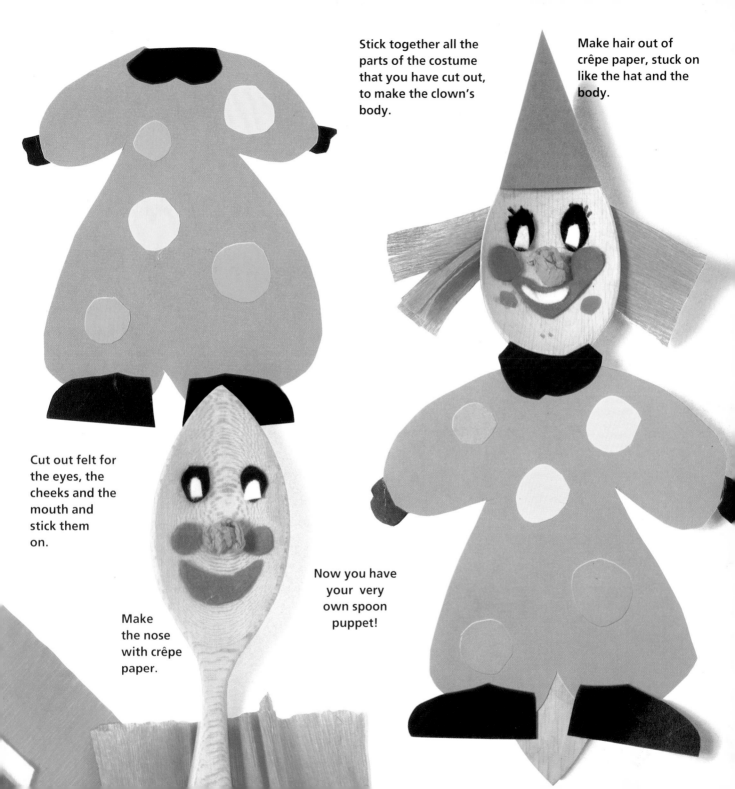

Stick together all the parts of the costume that you have cut out, to make the clown's body.

Make hair out of crêpe paper, stuck on like the hat and the body.

Cut out felt for the eyes, the cheeks and the mouth and stick them on.

Make the nose with crêpe paper.

Now you have your very own spoon puppet!

A butterfly

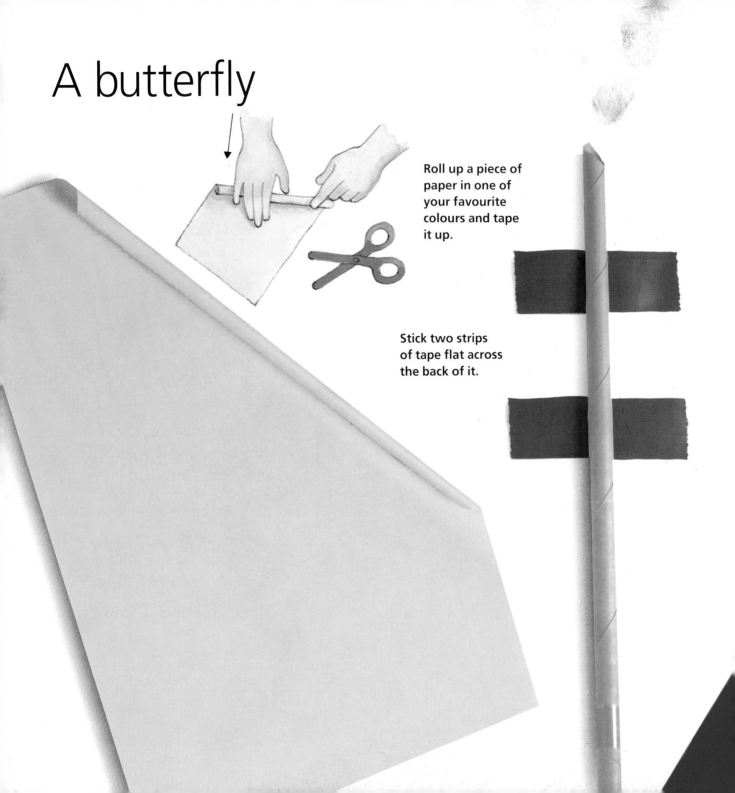

Roll up a piece of paper in one of your favourite colours and tape it up.

Stick two strips of tape flat across the back of it.

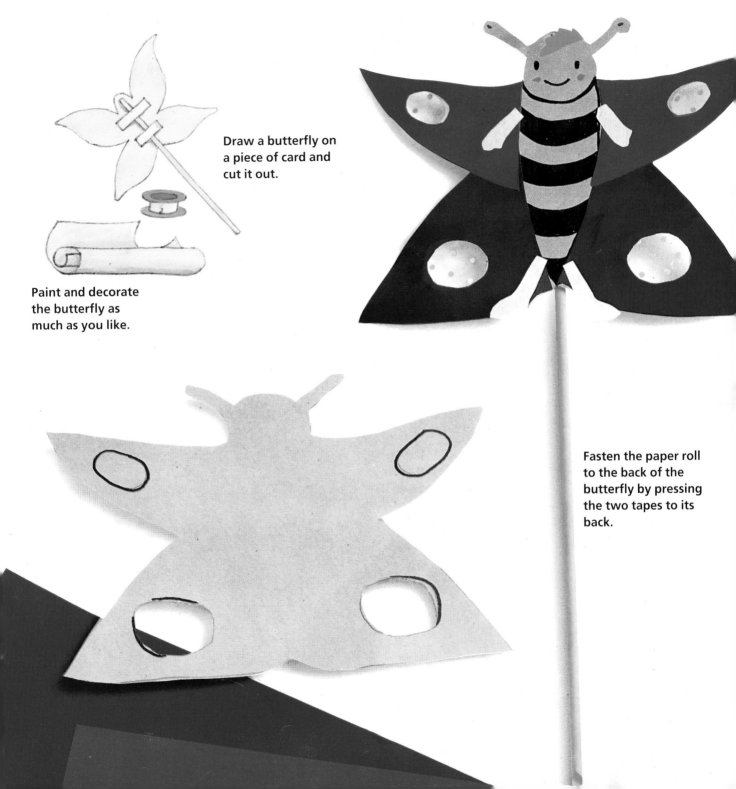

Draw a butterfly on
a piece of card and
cut it out.

Paint and decorate
the butterfly as
much as you like.

Fasten the paper roll
to the back of the
butterfly by pressing
the two tapes to its
back.

A handkerchief puppet

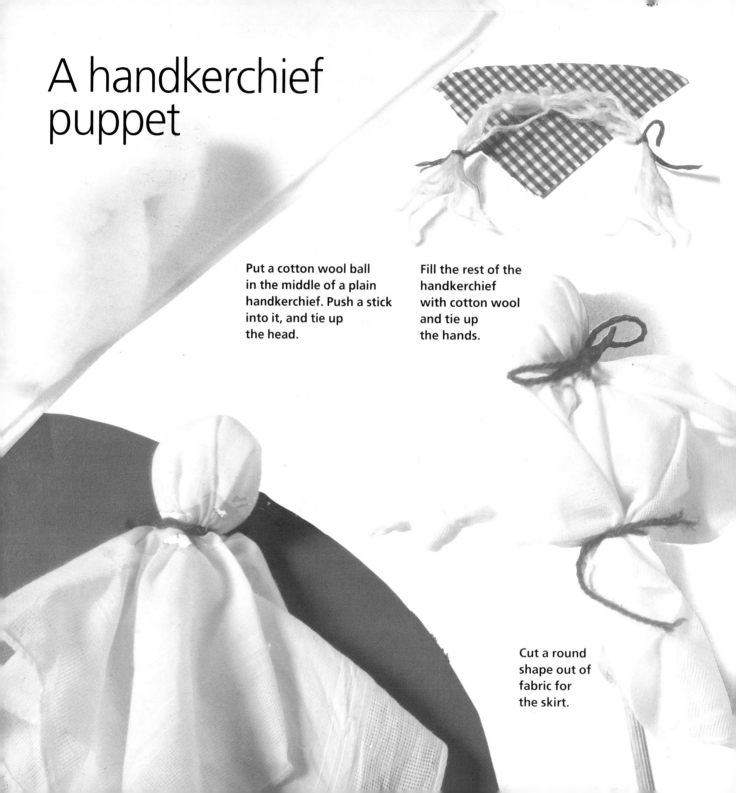

Put a cotton wool ball in the middle of a plain handkerchief. Push a stick into it, and tie up the head.

Fill the rest of the handkerchief with cotton wool and tie up the hands.

Cut a round shape out of fabric for the skirt.

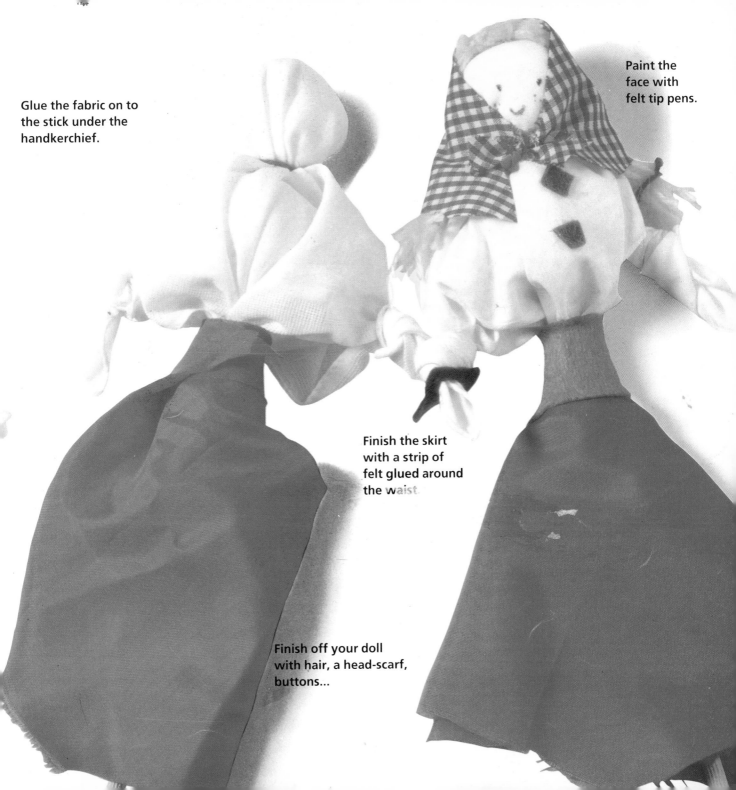

Glue the fabric on to the stick under the handkerchief.

Paint the face with felt tip pens.

Finish the skirt with a strip of felt glued around the waist.

Finish off your doll with hair, a head-scarf, buttons...

A wizard

Roll a piece of paper into a cone shape.

With other colours of paper, make a face, hands, a tie...

Make two holes for the arms.

Make the hat the same way: roll it up into a cone shape, too, and stick it to the body.

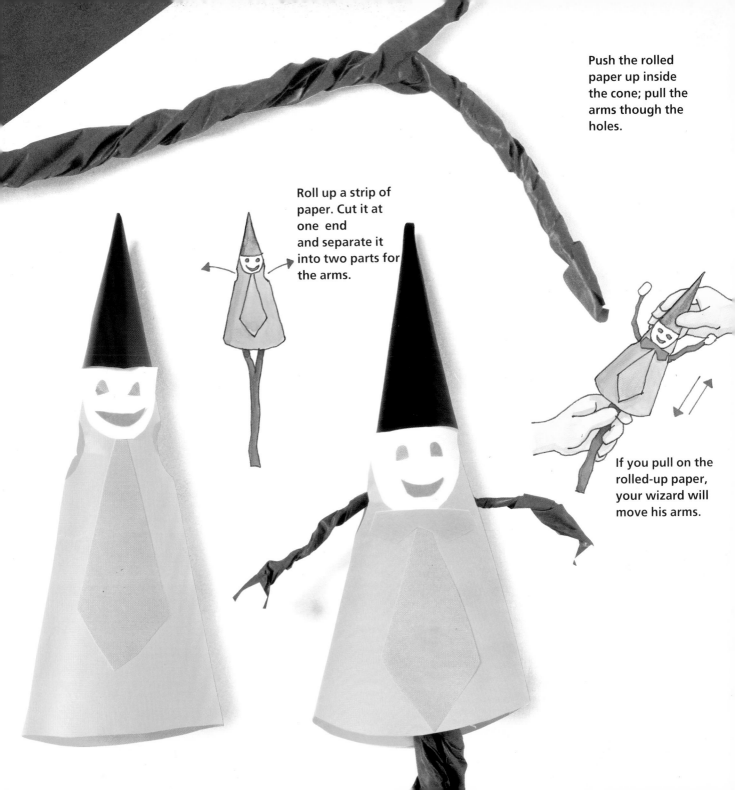

Push the rolled paper up inside the cone; pull the arms though the holes.

Roll up a strip of paper. Cut it at one end and separate it into two parts for the arms.

If you pull on the rolled-up paper, your wizard will move his arms.

Sun and moon

Draw the shape of a mitten on to a piece of fabric; cut two identical shapes. Stick them together along the curved edge.

On other pieces of fabric, draw shapes for the sun and the moon; cut them out.

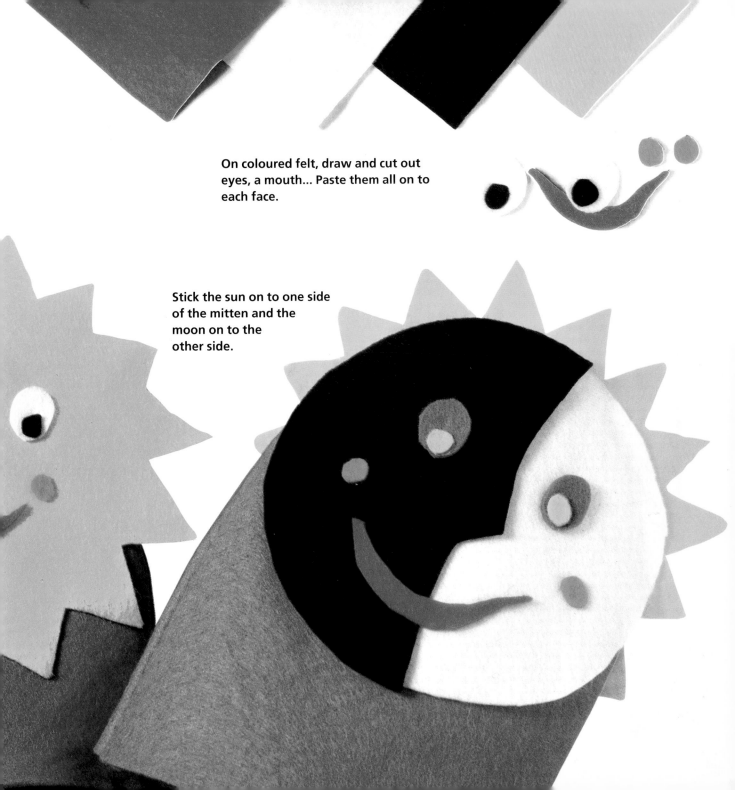

On coloured felt, draw and cut out eyes, a mouth... Paste them all on to each face.

Stick the sun on to one side of the mitten and the moon on to the other side.

A jumping crocodile

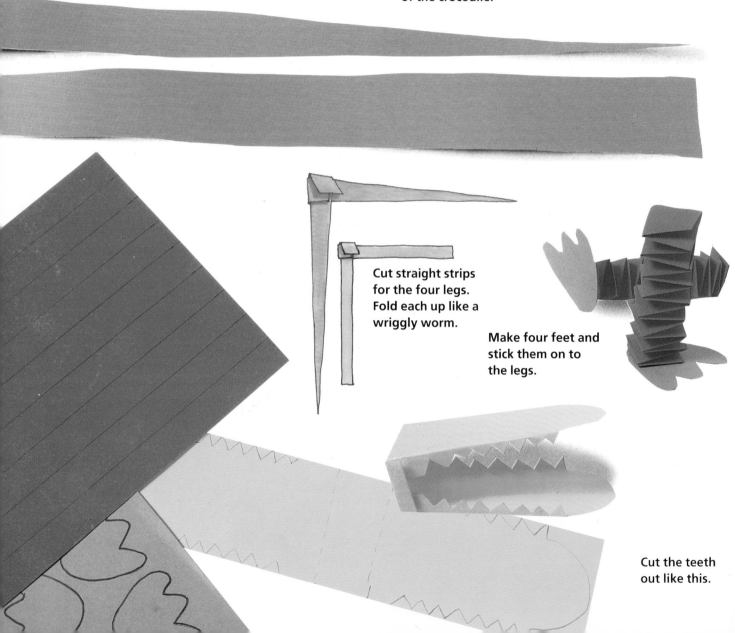

Cut out two strips of card. Make them wider at one end than at the other. They are the strips of the body of the crocodile.

Cut straight strips for the four legs. Fold each up like a wriggly worm.

Make four feet and stick them on to the legs.

Cut the teeth out like this.

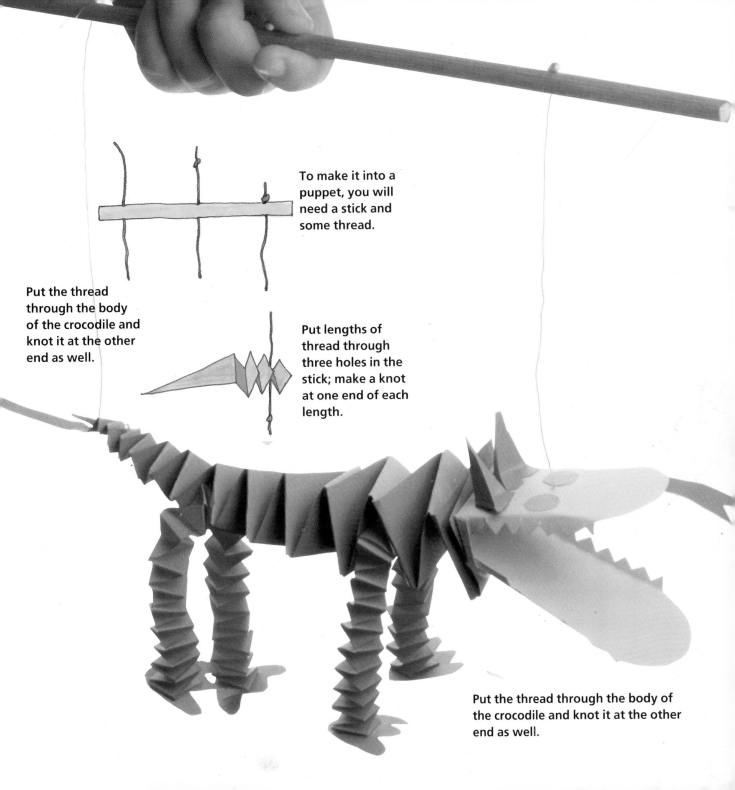

To make it into a puppet, you will need a stick and some thread.

Put the thread through the body of the crocodile and knot it at the other end as well.

Put lengths of thread through three holes in the stick; make a knot at one end of each length.

Put the thread through the body of the crocodile and knot it at the other end as well.

Dress up your fingers

Look for two old gloves, cotton wool, some wool and scraps of coloured material.

Cut the tips off the fingers of one glove.

Fill them with cotton wool.

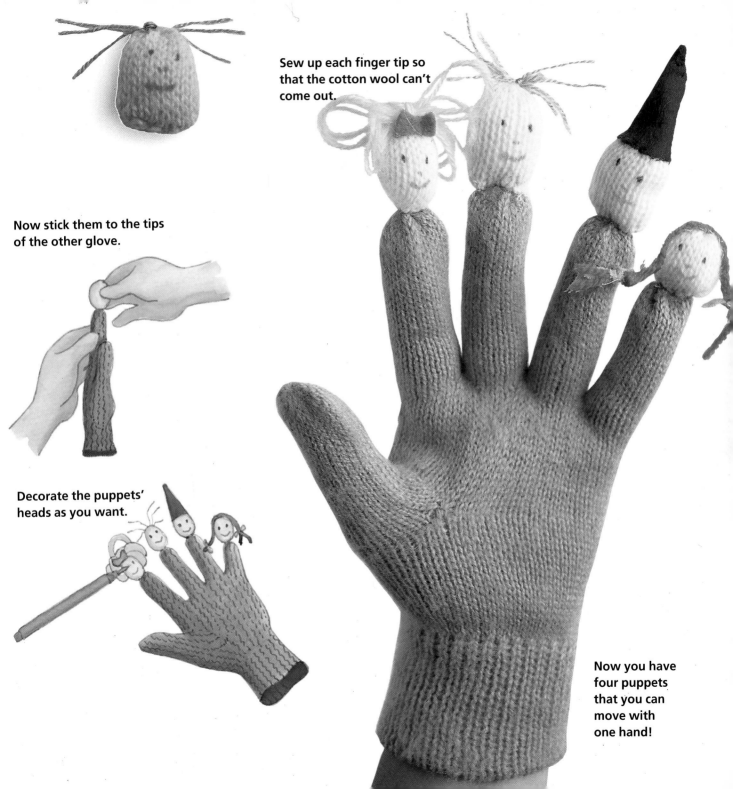

Sew up each finger tip so that the cotton wool can't come out.

Now stick them to the tips of the other glove.

Decorate the puppets' heads as you want.

Now you have four puppets that you can move with one hand!

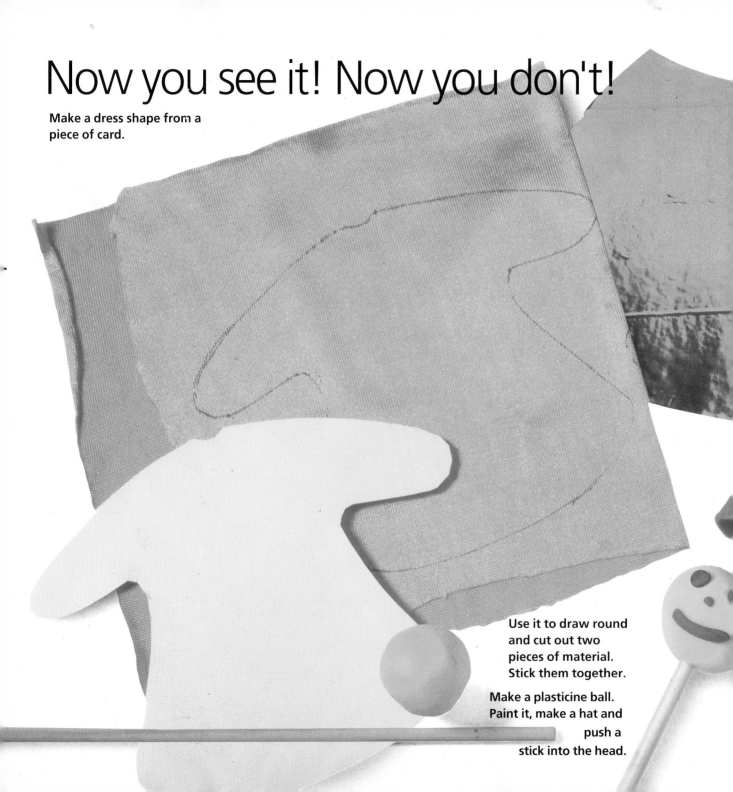

Now you see it! Now you don't!

**Make a dress shape from a
piece of card.**

**Use it to draw round
and cut out two
pieces of material.
Stick them together.**

**Make a plasticine ball.
Paint it, make a hat and
push a
stick into the head.**

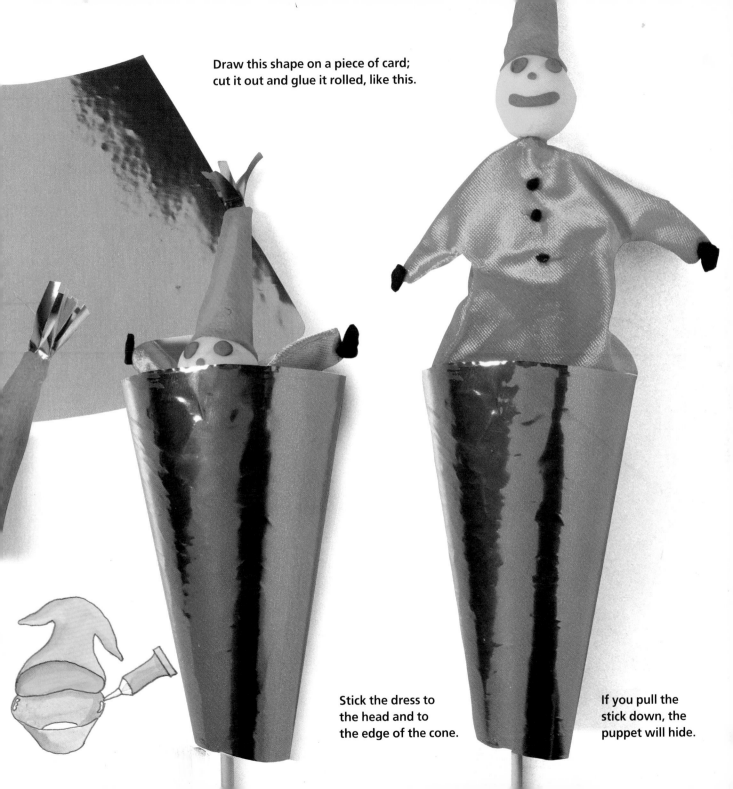

Draw this shape on a piece of card;
cut it out and glue it rolled, like this.

Stick the dress to
the head and to
the edge of the cone.

If you pull the
stick down, the
puppet will hide.

A waving clown

Make hands out of card, pull a thread through each hand and a piece of drinking straw and make a knot at the end.

You will need coloured card, tissue paper, sticky stars, straws, a stick and thread.

Make a body like the crocodile's, with two strips of card.

Make a hat by rolling and sticking card. Decorate it with stars.

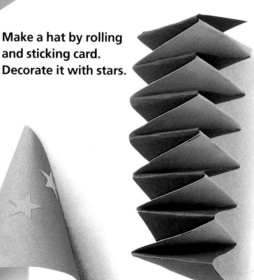

Make a head by scrumpling up some tissue paper.

Stick on details in card.

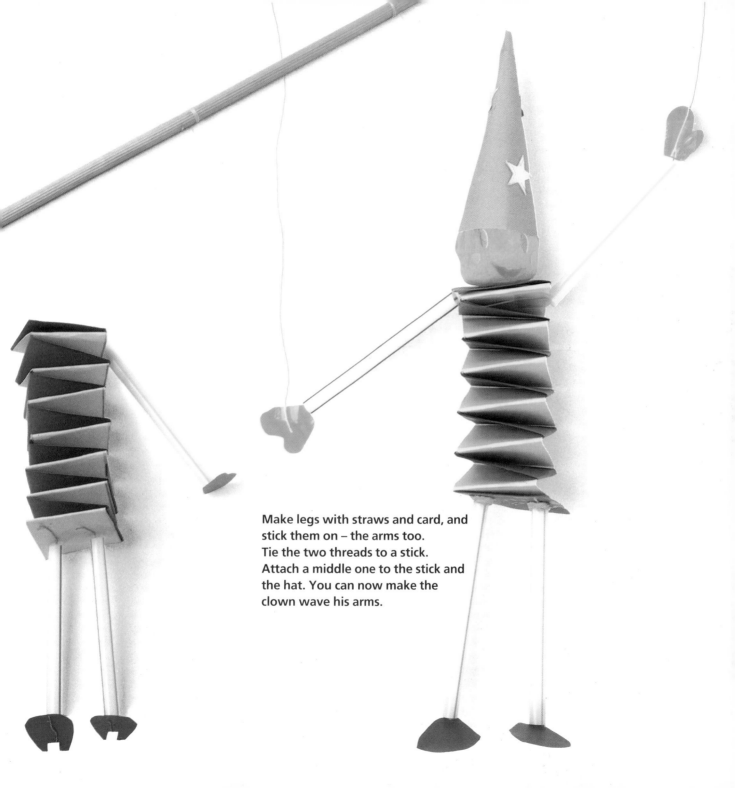

Make legs with straws and card, and stick them on – the arms too.
Tie the two threads to a stick.
Attach a middle one to the stick and the hat. You can now make the clown wave his arms.

Clay puppets

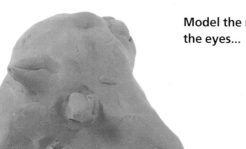

Make heads for Little Red Riding Hood and the wolf with balls of clay.

Model the mouth, the eyes...

Leave the clay to dry. Decorate the heads with coloured paints.

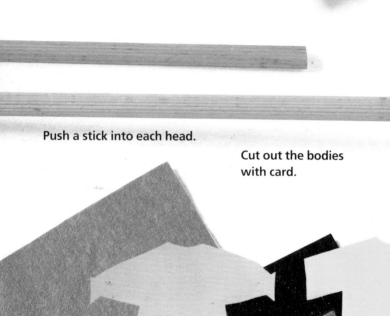

Push a stick into each head.

Cut out the bodies with card.

Stick the bodies to the heads like this.

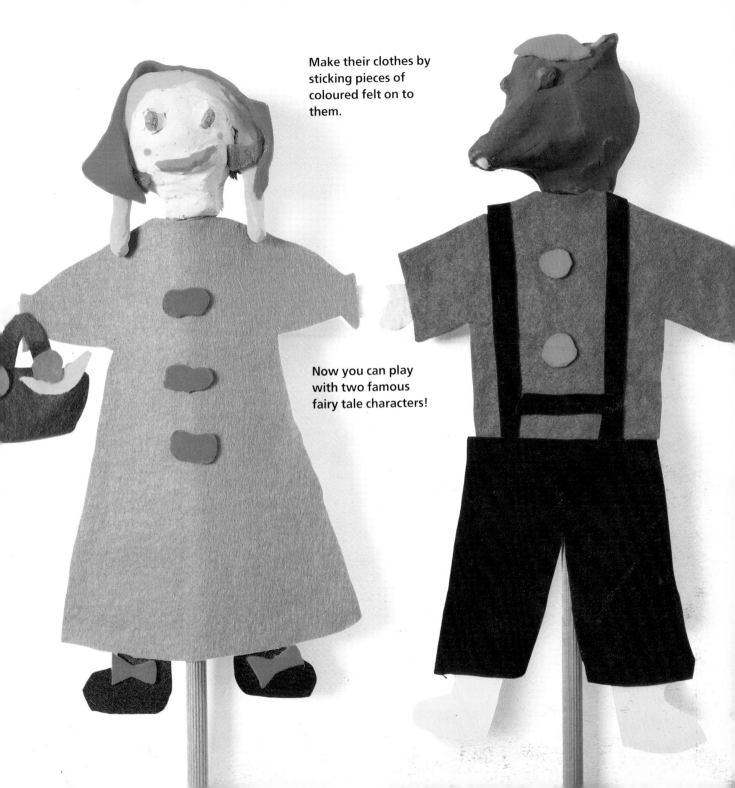

Make their clothes by sticking pieces of coloured felt on to them.

Now you can play with two famous fairy tale characters!

Plaster puppets

Cut up some bandages, like doctors use, into strips.

Soak the strips in plaster.

Blow a balloon up till it's about the size of a doll's head. Knot it.

Mould the shape of the eyes, the mouth...

Make a neck with a cardboard tube.

Cover the blown-up balloon and the cardboard with the bandages.

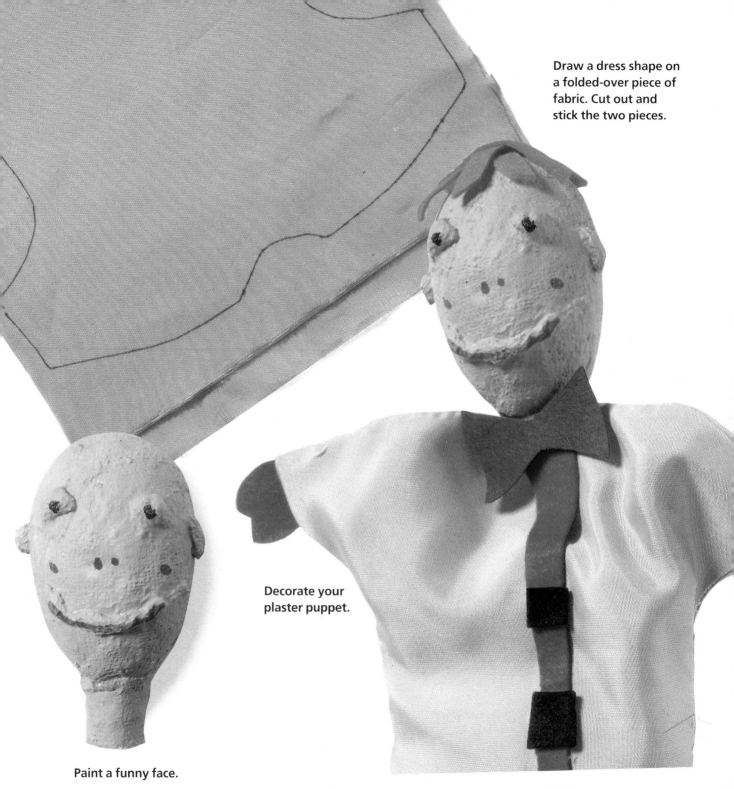

Draw a dress shape on a folded-over piece of fabric. Cut out and stick the two pieces.

Decorate your plaster puppet.

Paint a funny face.

Other books for children from Phaidon Press:

Have Fun with Crafts

Any child from 5 upwards will love the many ideas in this series. Packed with practical ideas and colourful illustrations.

Titles in the series:

HAVE FUN WITH PAPER
HAVE FUN WITH PLASTICINE
HAVE FUN MAKING PUPPETS

Learn to Paint and Draw

This highly attractive series of practical art books has been specially created for children between the ages of 7 and 12. Imaginative step-by-step exercises teach children to paint and draw whilst having fun.

Titles in the series:

LEARN TO DRAW WITH COLOURED PENCILS
LEARN TO DRAW WITH MARKERS
LEARN TO DRAW WITH PENCILS
LEARN TO PAINT WITH POSTER PAINT
LEARN TO PAINT WITH WATERCOLOUR
LEARN TO DRAW WITH WAX CRAYONS